Ex Libris

For Janice,
Kelly and Gregory
Who love this island

Nantucket Musings

An anthology of verse and photography
by
Albert J. Repicci

Nantucket Musings

by

Albert J. Repicci

Published by

K.H.P. Museum & Custom Publishing

Bethpage, NY 11714 U.S.A.

1 800 732 4KHP

Front image: Trail to **Steps Beach**
Back image: Dunes leading to **Dionis Beach**

Printed in Korea

ISBN 1-930348-00-2 KHCP 599

Photographs used in this book are from the Author's collection with additional photography by William Haggerty.

Acknowledgement:
I would like to extend my appreciation to David Butterfield, without whose editorial guidance this book would not have been possible. My special thanks and gratitude go to my good friend and colleague, Bill Haggerty, for his permission to use six beautiful images from his personal collection. A. J. R.

The Centurians

Dark insipid gloom foreboding
Fiends and demons of despair,
While heart and strength so fast eroding
Luring to its vapid lair.

Rife with anguish soul forsaken
Shrouded by the lords of night,
Cast a pall on spirits broken
Haunting shadows sow the blight.

Yet to the rampart *hope* must quicken
Standing vigil where 'er you roam,
With *faith* as beacon for the stricken
Hand in hand to guide you home.

Dr. Repicci is donating all proceeds from this edition of Nantucket Musings to the
International Medical Mission (MMI) which with over 50 hands-on clinical projects a year provides hope
through medical and dental care to 20 of the world's most impoverished nations.

MMI is headquartered in Plano, Texas.

Albert J. Repicci

Albert J. Repicci began his studies as an English major and pre-dental student at the University of Buffalo before receiving his Doctorate in Dental Medicine at the University of Pennsylvania and subsequent study of orthodontics at Columbia University. While in the private practice of orthodontics in Greenwich, Connecticut, Repicci continued to draw from his liberal arts background with his writing as well as with his involvement in the performing arts as an associate producer of several Off Broadway productions.

Combining his inclination for writing, photography and adventure with his work in the dental profession, Repicci has also chronicled his observations of people and places encountered in dental projects in some of the remotest corners of the world.

Of all the places visited in his travels, Repicci claims that Nantucket holds a special place in his heart. Not having missed a summer there since his first visit more than 30 years ago, Repicci says he was seduced by the island's landscape, architecture and... its ghosts.

Enticed by the muse on Nantucket's shores, this collection of wistful verses and photographs was spawned out of pure serendipity as a gift that simply says,

"On this beautiful island.... I'm thinking of you".

A Sleeping Beauty

Once upon a time, there was a far away island, nestled in the Atlantic Ocean, twenty miles off the coast of Cape Cod, where Native American Indians farmed, fished and occasionally plied the waters of Nantucket hunting whales.

When the first European settlers came to Nantucket to graze their sheep, they lived and worked in harmony with the indigenous people. In time these settlers learned the art of whaling from them, and because of the demand for the pure oil found in the skull of the sperm whale, turned that skill into a burgeoning industry which would be recognized as the most prolific in the world.

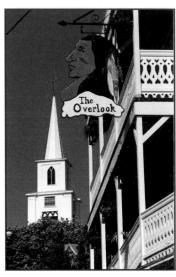

Photograph by A.J. Repicci

The **Old North Church Steeple** towers above the Overlook hotel.

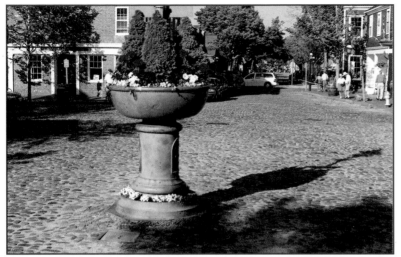

Photograph by A.J. Repicci

Cobblestone streets, which have endured the centuries, course their way through downtown **Nantucket.**

With its tall ships, cobblestone streets, rolling heaths and trim, grey shingled houses, early 19th Century Nantucket flourished. Stories abound of those halcyon days of Nantucket's Golden Period where the confluence of intellectual discourse, Quaker utilitarianism, science and commerce generated the folklore which made Nantucket a centerpiece of New England history and legend.

Tragically, however, in the mid-1800's a seemingly apocalyptic series of events led to the decline of Nantucket's preeminence in the world of trade and commerce. The formation of a sandbar in Nantucket Harbor, preventing cargo laden ships from reaching the pier, was a harbinger of misfortunes yet to come.

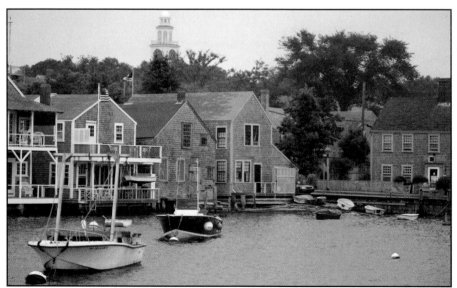

Photograph by W. Haggerty

A gentle mist brings a quiet hush over **Old North Wharf** in Nantucket Harbor.

Sea-faring images grace the merchant district.

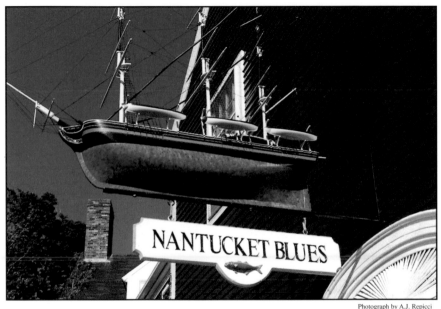

The Great Fire of 1846 destroyed most of Nantucket's downtown and commercial district. Combining this with the Gold Rush of 1849, which lured many an able-bodied seaman away from the long and arduous whaling expeditions, (centered as far away as the Pacific), the discovery of "land oil", and the Civil War's isolating effects, all proved collectively cataclysmic for Nantucket's future.

As tragic as these events were for 19th Century Nantucket, the seeds for its resurrection nearly a hundred years later were already being sown. During the second half of the 20th Century, Nantucket began to quietly awaken from near dormancy as the brambles were being stripped away from this ingenue in repose.

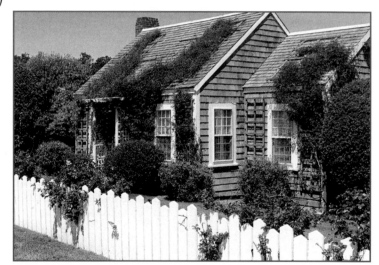

Country cottage on **Polpis Road,** monikered, "By The Way".

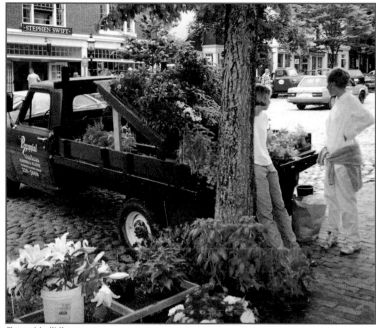

Beginning the day on **Main Street** with fresh flowers and produce.

Having experienced little
development or change
over the ages, and with its
Golden Period ambiance
being uncovered virtually
intact, Nantucket stood
poised for its renaissance.

Unspoiled heaths, primordial ponds, period architectural integrity, windmills, pristine beaches and graceful dunes all stand as a living monument of another age to be lived and enjoyed by us today.

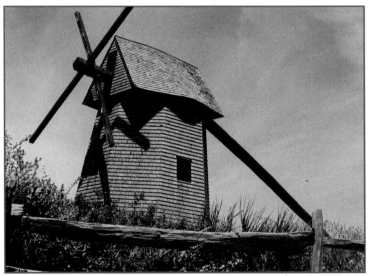

The Old Mill on Prospect Hill still grinds corn as it did when built in 1746.

Photograph by A.J. Repicci

Quaker sea captain watches vigil over the entrance to **Brant Point** harbor-side homes.

So welcome........

to this treasure of an island...

this sleeping beauty.

Nantucket

Think upon a friend when you view
something of rare beauty
worthy of your notice,
that they may be
partakers in your
happiness.

Freely adapted from W. Shakespeare

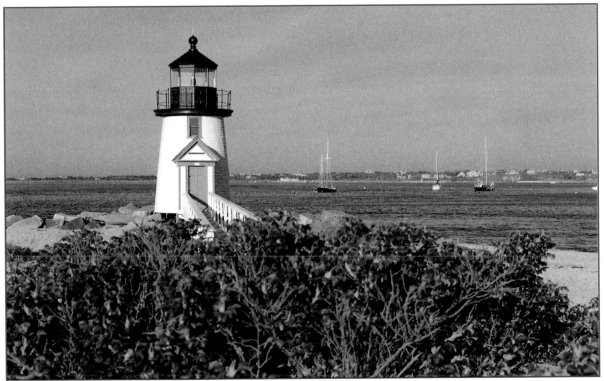

Brant Point Lighthouse has been welcoming and bidding safe voyage to vessels since 1746.

First Sighting

Eagle turns 'round Brant Point Light
With golden steeple now in sight,
At harbor's edge, soon friends you'll meet
With cobblestones beneath your feet,
Far at sea, free from strife
Where summer dreams all come to life.

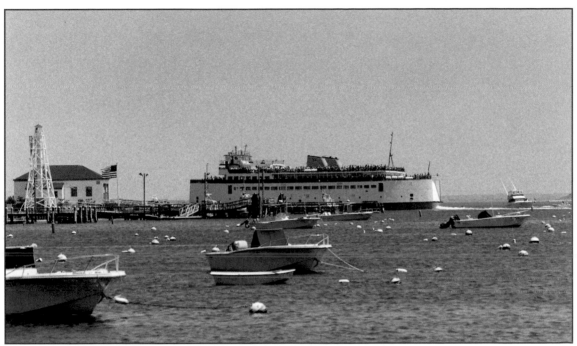

The Eagle, largest of the steamships arriving from Hyannis, cruises past Brant Point
providing passengers with their first full view of Nantucket.

The Isle

A distant isle well out to sea
Set in mid-ocean's foam
Where breaching whales and sailor's tales
And Quakers made their home.

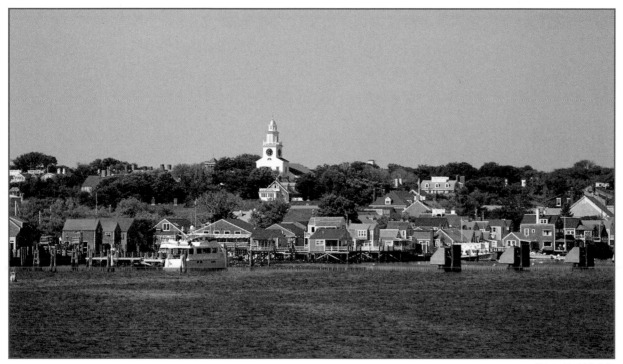

The golden dome of **The Unitarian Church** rises high above the town with Old North Wharf in the foreground. From the clocktower, its Portuguese bell tolls a wake-up notice, a mid-day call and announces the day's end.

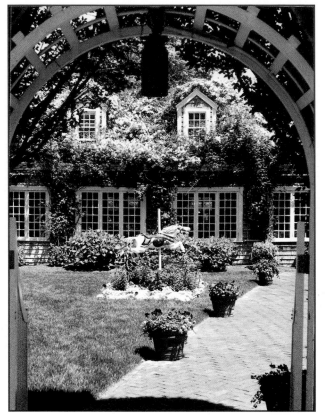

The romantic rose garden
entrance and carousel horse
welcome diners to
The Chanticleer in the village
of **Siasconset**.

A Dream

Kids rubbing noses
The heart string composes
A lover proposes
Come smell the roses.

Keeping faith with our children

Never pass a lemonade stand.

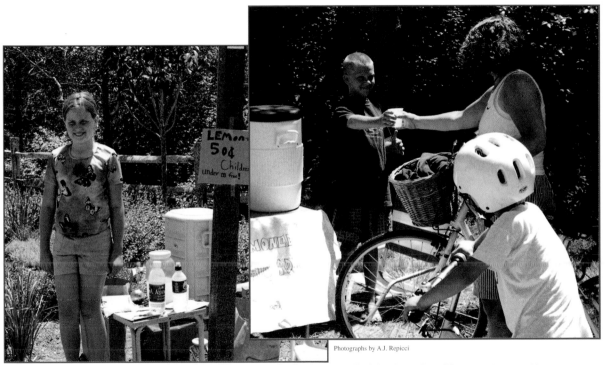

Photographs by A.J. Repicci

Entrepreneurs, Maggie and David are open for business on the bicycle trail to **Siasconset**, quenching your thirst with a drink and touching your heart with a smile.

The Steps

Along the Steps where the rose hip blooms
Lie soft evening shadows of prints in the dunes.

Sun edging westward soon laid to rest
Another day passed, another day blest.

Photograph by A.J. Repicci

Just west of the **Jetties**, descending from **The Cliffs** to the shore, rows of steps lead through the rose hip and sandy dunes to **Steps Beach**.

The Gift

That peace to man God shall bequeath
The hush that lingers in the heath,
That stillness 'neath a mist unfolding
For us to Him we stand beholding.

A quiet rolling upland heath, characterized by bearberry, mealy plum, bayberry and huckleberry,
viewed from **Polpis Road**

The real you is who you are when you're

alone.

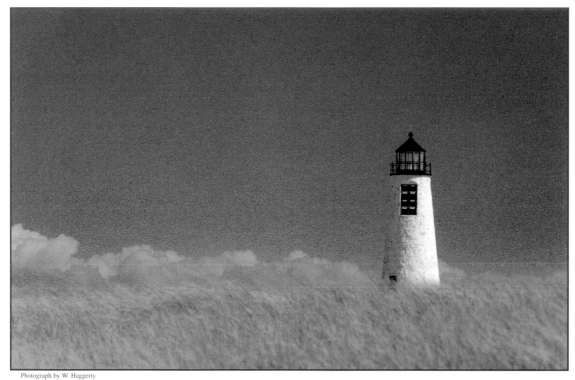

Photograph by W. Haggerty

Great Point Lighthouse, at the northern tip of the island, stands serenely
steadfast as a quiet beacon to ships at sea.

On Polpis Road and beyond

On Polpis Road

I saw a toad

Leap into the heather,

A thrush

Then scurried through

The brush

Before it took to feather.

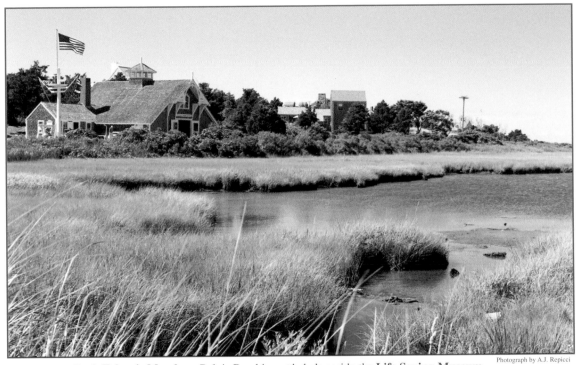

Lush **Folger's Marsh** on Polpis Road is nestled alongside the **Life Saving Museum**.

.... and beyond

On Alter Rock

A pheasant cock

Chortled for his mate,

While Mr. Rabbit

As is his habit

Was late for another date.....

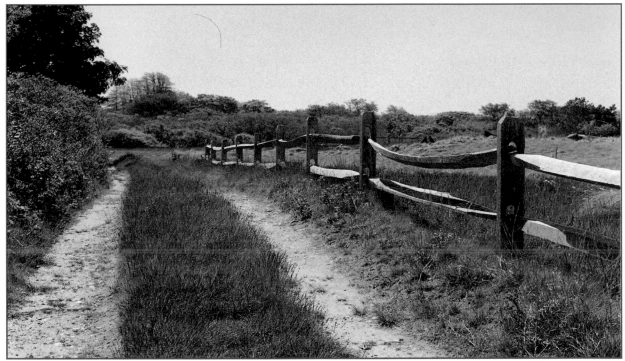

Country trail off Polpis Road rambles up through the brush-lands area of **Alter Rock**.

Photograph by A.J. Repicci

.... and beyond

Near the cranberry bog

I began to jog

When a deer leapt down the trail,

With a sudden flick

he discharged a tick

From its perch upon his tail.

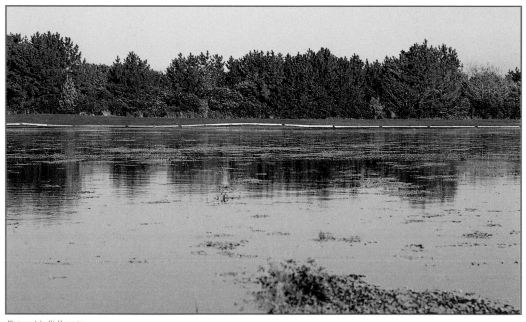

Photograph by W. Haggerty An autumn spectacle of cranberries floating in a flooded bog on **Polpis Road**

.... and beyond

Now it isn't often

That Jethro Coffin

Built a cottage for his spouse,

But on Sunset Hill

It stands there still

as Nantucket's oldest house.

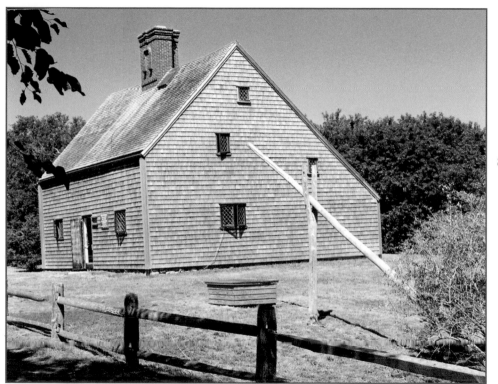

The Jethro Coffin House
(or Horseshoe House, so named for the horseshoe design on the chimney) was built on **Sunset Hill** in 1686 as a wedding gift from the families of Jethro Coffin and Mary Gardner.

Photograph by A.J. Repicci

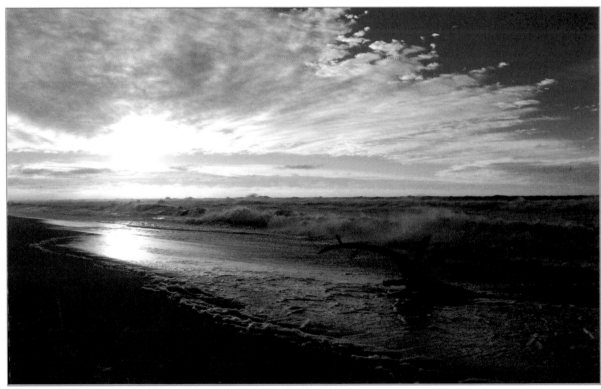

Photograph by W. Haggerty

.... and beyond.

By the sea I sat
At Madaket
While the sun was on the wane,
Soon again to rise
In the eastern skies
Warming 'Sconset's arbored lanes.

The Great Bike Race

My mother and I
Thought a bike race we'd try
From Pocomo out to Wauwinet,
The old gal was game
As I suffered the shame
From the rear as I watched
My ma win it.

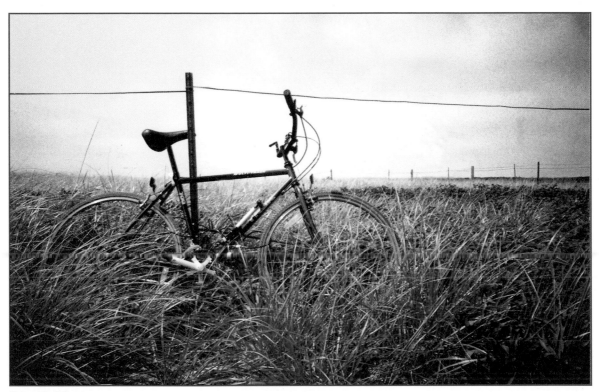

Bicycle in repose

Ram Pasture

A stroll down Ram Pasture's sandy trail
with osprey, deer and cottontail,
Where yarro, bluets and Joe-pye weed,
Carpet meadows sparsely treed.

In summer breeze they bend with grace,
A frothy sea of Queen Anne's lace,
Near Hummock Pond to search one's soul,
seated by a meadow vole.

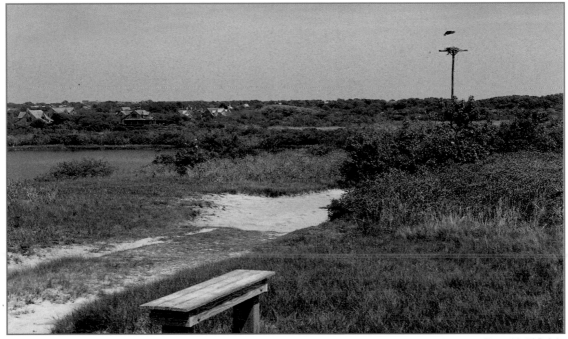

Osprey hovers over its nest above **Hummock Pond** at **Sanford Farm** and **Ram Pasture**.

Hither and Thither

As elusive a creek as is Hither,
The conundrum is whither is Thither.
As the tides come and go,
Hither flows to and fro,
So when Hither's not hither...it's Thither.

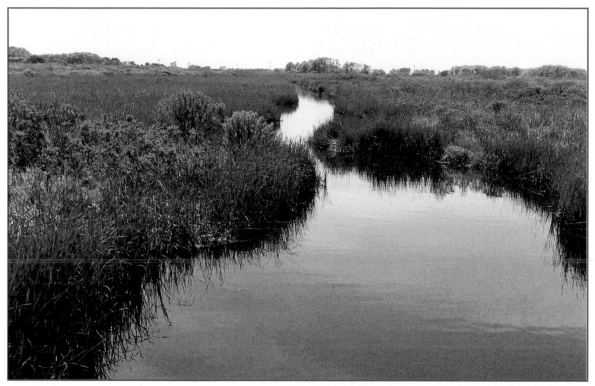

Hither Creek meandering through the marsh from **Madaket Harbor** to **Long Pond**

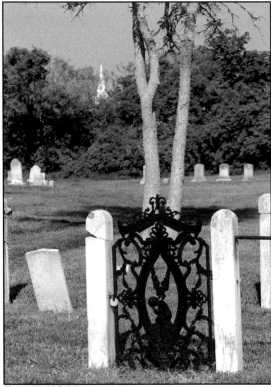

The Old North Cemetery

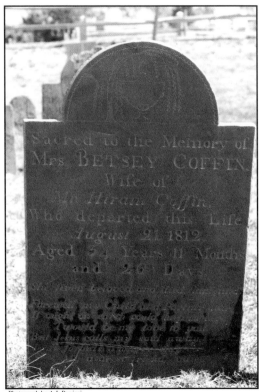

Sacred to the Memory of
Mrs. BETSEY COFFIN,
Wife of
Mr. Hiram Coffin,
Who departed this Life
August 21, 1812.
Aged 54 Years 11 Months
and 26 Days.

The Grave of Betsey Coffin

Sacred to the memory of

Mrs. Betsey Coffin

wife of Mr. Hiram Coffin

who departed this life, August 21, 1812

aged 34 years, 11 months and 26 days.

" She lived beloved and died lamented."

A lost love.....

A love left behind

Farewell my child and partner dear

If ought on earth could keep me here.

'Twould be my love for you

but Jesus calls my soul away

Jesus forbids a longer stay

My dearest friend.....adieu.

The Beckoning

Quiet lanes and arbors draped
with flowers full in bloom,
The ghost of ancient mariners
In every shadow loom.
This haunting visage lingers
as you near vacation's end,
Fear not; the sirens of the Isle
Will summon you again.

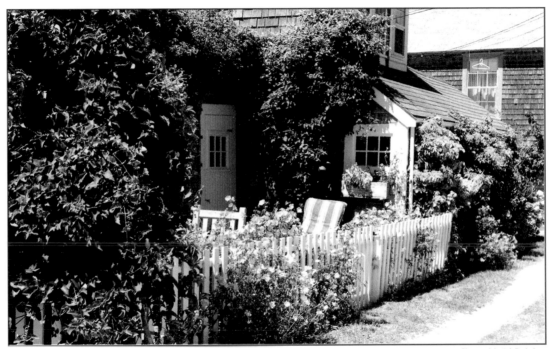

Trim cottages adorned with blossoms typify the quiet lanes of **Siasconset.**

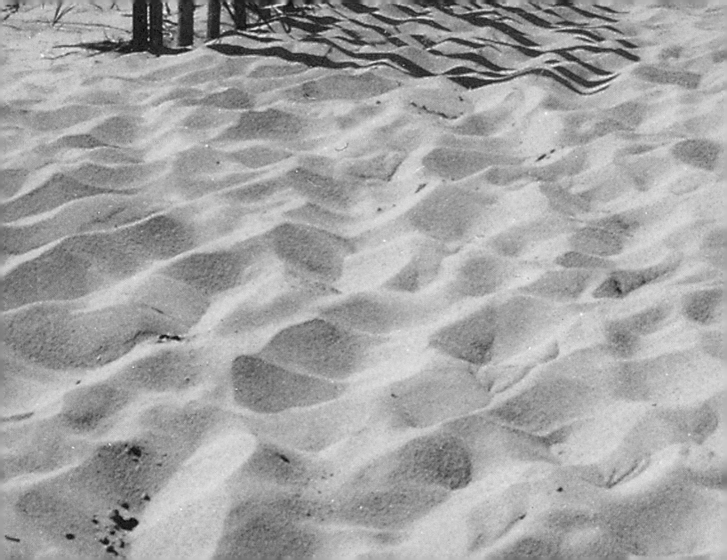